CUBA
TV

Cuba TV
© Simone Lueck

Without limiting the rights under copyright reserved above, no part of this publication may be used, reproduced, stored, transmitted or copied in any form or by any means (electronic, mechanical, photocopying, or otherwise) without prior written permission, except in the case of short excerpts embodied in critical articles and reviews.

Every effort has been made to trace accurate ownership of copyrighted text and visual materials used in this book. Errors or omissions will be corrected in subsequent editions, provided notification is sent to the publisher.

Library of Congress Control Number: 2010941686

Printed and bound in China through Asia Pacific Offset.

10 9 8 7 6 5 4 3 2 1 First edition

This edition © 2011
Mark Batty Publisher
68 Jay Street, Suite 410
Brooklyn, NY 11201
www.markbattypublisher.com

ISBN: 978-1-9356132-6-8

Distributed outside North America by:
Thames & Hudson Ltd
181A High Holborn
London WC1V 7QX
United Kingdom
Tel: 00 44 20 7845 5000
Fax: 00 44 20 7845 5055
www.thameshudson.co.uk

By SIMONE LUECK

Mark Batty Publisher
· New York, 2011 ·

FOREWORD

If taking a picture of a TV is like taking a picture of a mirror, and I think it is, then there's something weirdly vain about this whole thing, isn't there? Because you can't take a picture of a mirror without getting yourself in the shot. Dodging around only does so much good; the evidence is still there in the framing, the tilt— the same loci that always betray the hands that hold the cameras.

Simone Lueck is in these photos if you know where to look. Most of these shots are taken at hip-level, you can tell. I also know this because I've personally seen Lueck take one or two thousand photos. She's at once the most conspicuous of photographers—elbows likely to take out someone's eye, prone to unexpected and often terrifying outbursts of enthusiasm—and the most chameleon-like, because there's just no way someone of such look-at-me noise and movement could create images of such burning stillness. In this collection of photos, the same details of inertia get me every time: rocking chairs in full-back position; people's spines locked into the most familiar of curves; televisions weighed down by a million secret things. And none of it going anywhere, from the look of it.

You think Lueck knew what she was getting herself into when she landed in Cuba? You're nuts. What she did was invite herself inside people's homes. After that, the TV sets just reeled her in. This blind magnetism is something she's prone to. Example: she took stills on a movie I made, and one day I realized she wasn't getting enough shots of Actor A but was lavishing attention upon Actor B. When I told her to even out the ratio a little, she was less than apologetic. I'd go so far as to say she was affronted. The planes of Actor B's skull, she'd discovered, were pleasing to her, and that was that. I ended up with some great shots of Actor B, of course, just sitting around, looking good, doing nothing.

Simone would have been more taken, I suspect, had I shot my movie in Cuba. The entire country is a set from an old film, a photographer's paradise. I bet you couldn't throw your camera out the window without it capturing at least a fantastically colored blur. So imagine it: Lueck, the kind of person who'd stick out in Venice Beach, bopping about the streets of Havana, knocking on doors and winding her way to each home's flickering heart.

She grew up in St. Paul, Minnesota—she doesn't have a camera bag, she has a camera beyg—and she probably spent her formative years drifting from one tube to the next in a dozen interchangeable suburban living rooms. But these sets in Cuba are different. Long umbilical cords snake off to outlets unknown. Knobs so space-age that they couldn't have ever been functional. A green hue makes each *telenovela* look like it takes place aboard a submarine. None of it makes sense, it's all impossible. These rickety old boxes Lueck discovered in plain sight look to be the secret machines powering the entire façade of Cuba.

Be it St. Paul or Havana, one thing holds true about TVs: what's being broadcast through them doesn't much matter. The objects themselves impart significance. Plastic casing tells the reassuring fable of mass production; curved glass proves the existence of perfection, dancing dust the possibility of magic; the wild hair of cables and antennae might as well be a dead (though very romantic) language for all we understand of it.

Some of the TVs Lueck shot are like bright white windows, the only escape from windowless cloisters, which, if you want to get political for a second, says something about Cuba. Other times, the TVs sit there like a member of the family, as loved, loathed, or ignored as anyone else. It's probably too easy to see altars

in shots so festooned with icons, but the sense of a religious connection between humans and their TVs is nowhere stronger than in the photo where a little eight-incher flickers happily atop a bigger (and deader) forbearer. The latter is kept because why? It meant something? There's a chance, however slim, that it might be repaired? Or is it simply the brutal economics of survival, because the second TV is easier to see when propped atop the first, just as the third TV will be even easier than that. You can imagine a whole tower and a series of necks craned in pious awe—look, there's religion again.

Besides, isn't it TV that will usher us into that long, dark night? Some evening, not too far away, we'll be on our sofas, sick with our final infection, and our TV will make the whispers that assure us that everything is okay: weight-loss drugs are still being hawked, young athletes still supersede their heroes, folks are still spinning wheels and winning big money. Or we'll be in a hospital bed, our ultimate one, and the only thing to distract us from our metronome beeps will be the glowing box craning down from the ceiling. Cathode ray, LCD, plasma, the size of a whole wall, the dimensions of a paperback, the specifics don't matter—Simone Lueck's photos remind us of this, over and over. We'll let it be the night nurse regardless. We'll forget to thank it on the way out. We always have.

Daniel Kraus

February 8, 2011
Chicago, Illinois

INTRO

All I knew about Cuba was that people drove old American cars and that Che Guevara was tied with Bob Marley as most popular poster in dorm rooms. Then my friend Erin invited me on a two-week trip to Havana.

I immediately fell in love with the people, the music and the dark city streets. In Havana there weren't any streetlights or porch lights or living room lamps. And even if there were, there wasn't enough electricity to power any of it. The streets were pitch black at night, except for the faint, beautiful glow of televisions spilling out of open doors and windows.

It seemed that every bit of electricity was used to power televisions, and everybody had a set. I decided to make these photographs as a fun way to introduce myself to strangers and to get inside their homes. It was fascinating to see what people watched and how they arranged their treasured belongings around the TV.

As a blond girl from the United States, people were as curious about me as I was about them. Each time I came across an open door and a working TV set, I would ask if I could take a picture of it. The answer was always yes, nobody seemed to think it was an odd request, and it was usually accompanied by a Cuban coffee or rum.

They all told me about The Bearded One, but they never mentioned his name. I told them how much I liked their city. They showed me pictures of relatives who had moved to the United States. I nodded and smiled often, hoping to communicate through these gestures, as I understood only every other word. Our uneven conversation was easily interrupted with sounds from the TV—a newsman speaking in a low baritone about something that sounded very important; the high-pitched screams of a soap opera star as she attempted, in vain, to save her lover from sinking into the quick sand; an American movie featuring a super loud car chase. These sounds became an organic element of our communication, and we would chat until I ran out of Spanish words.

The TV sets are outdated, pre-revolution relics imported from America, or Russia; green-hued beasts jury-rigged with computer parts and other discarded technological talismans, fantastically adorned like religious altars. In Cuba, television is a national pastime. The government controls all media, including the three main newspapers as well as the four television stations. The stations broadcast news reports, baseball, educational programs, soap operas, and Hollywood movies. Whether used for information or as a background for socializing and drinking rum, during broadcast hours, all TVs in Cuba are ON.

Simone Lueck

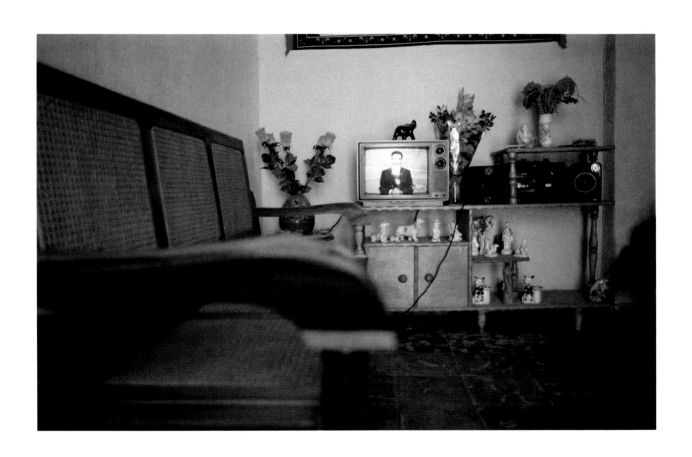

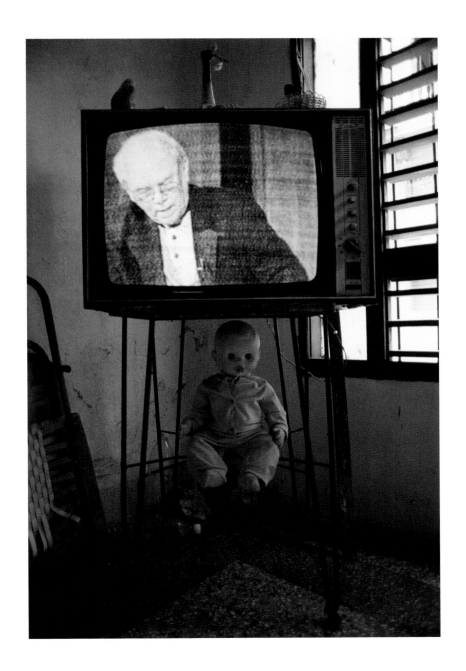

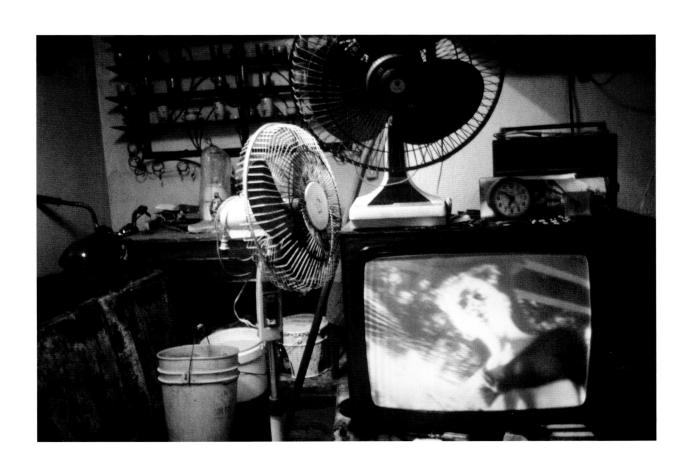

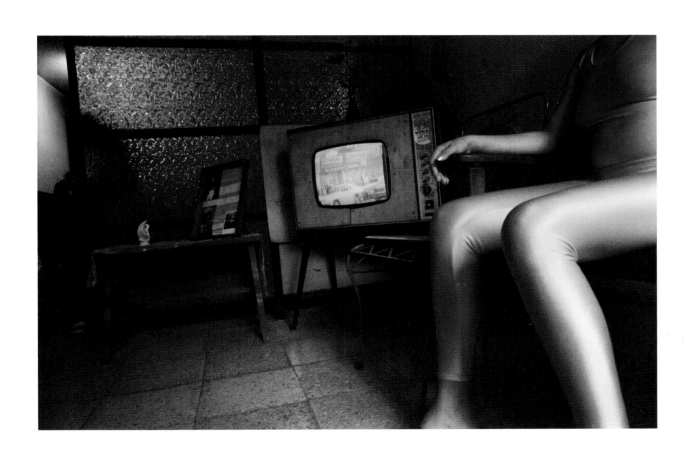

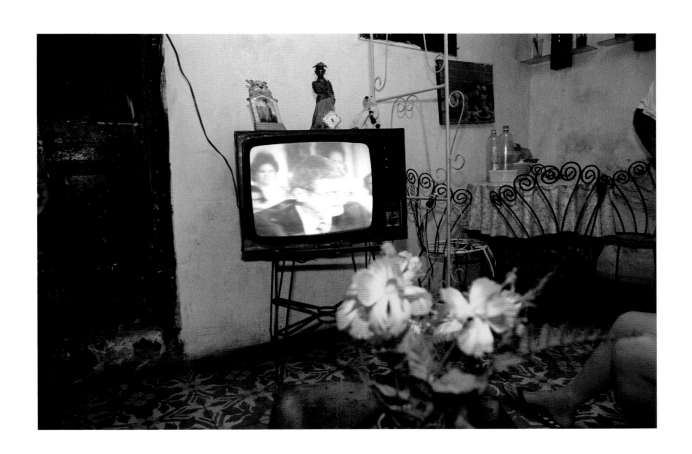

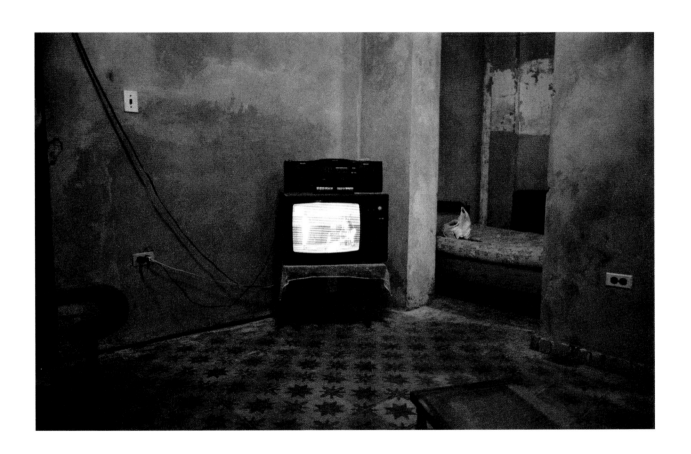

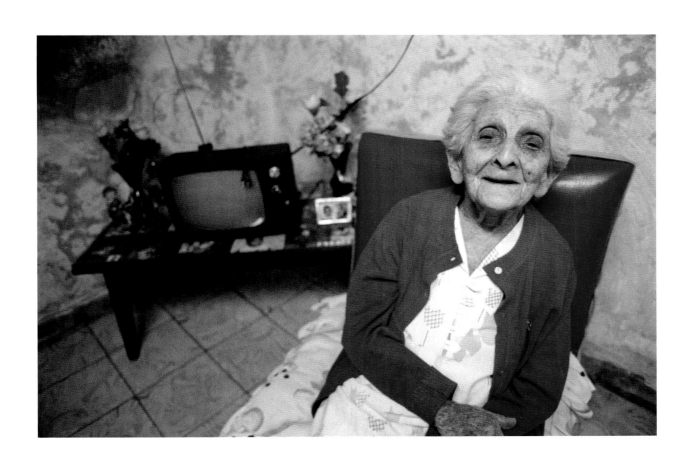

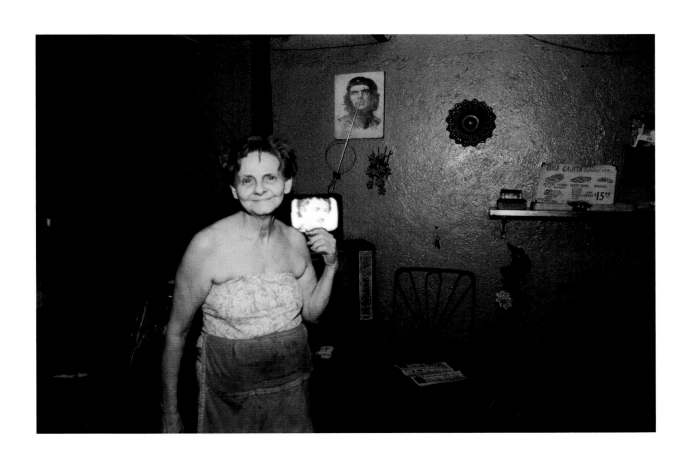

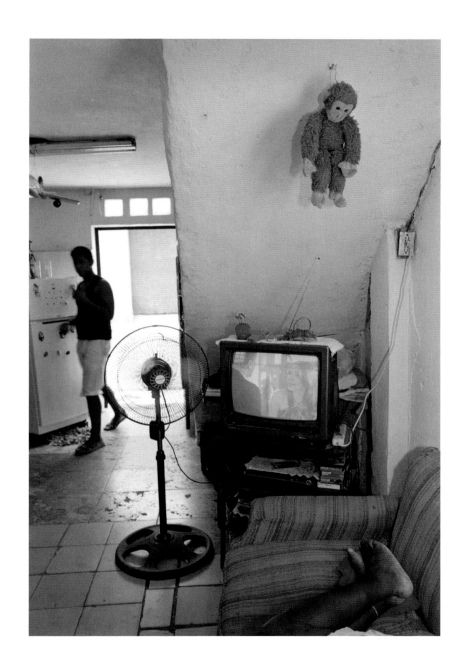

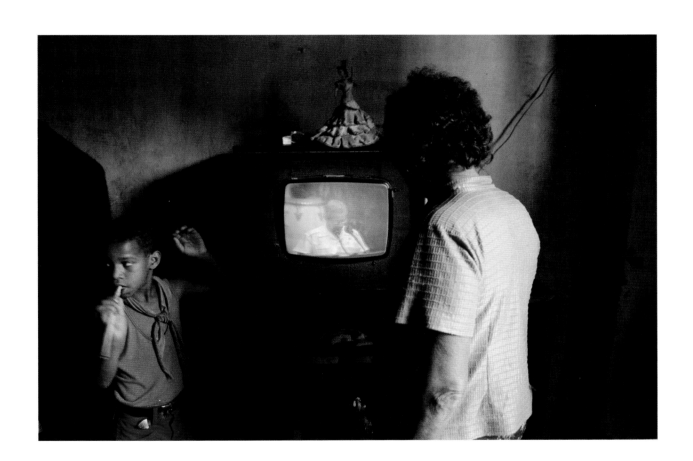

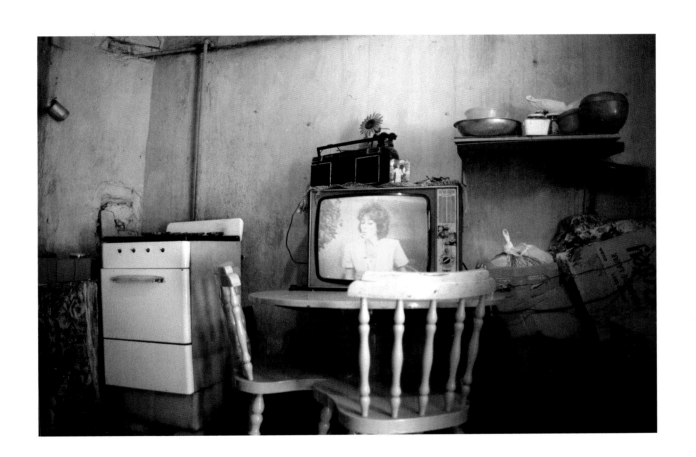

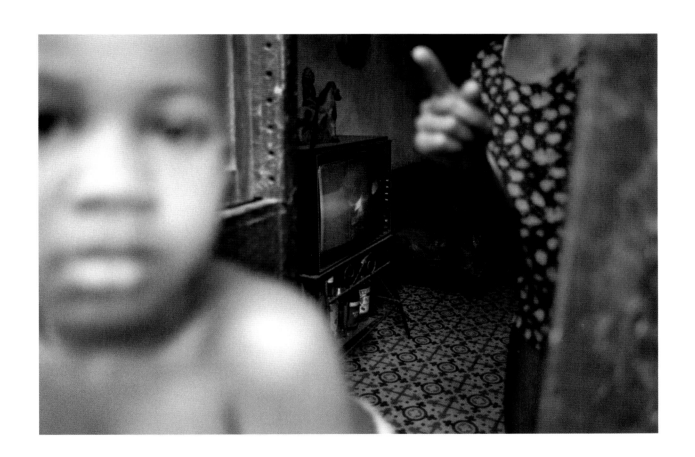

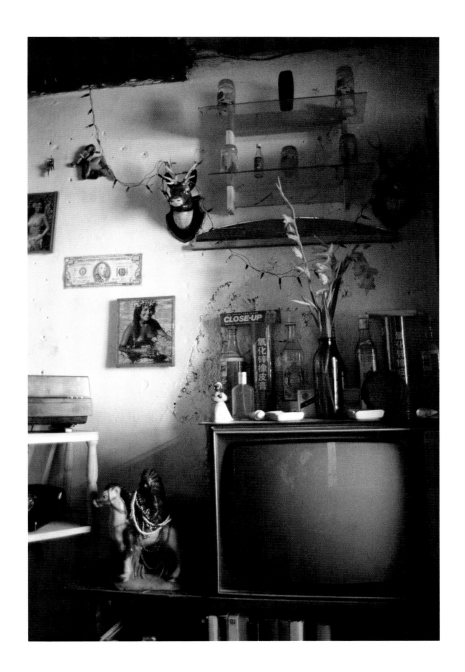

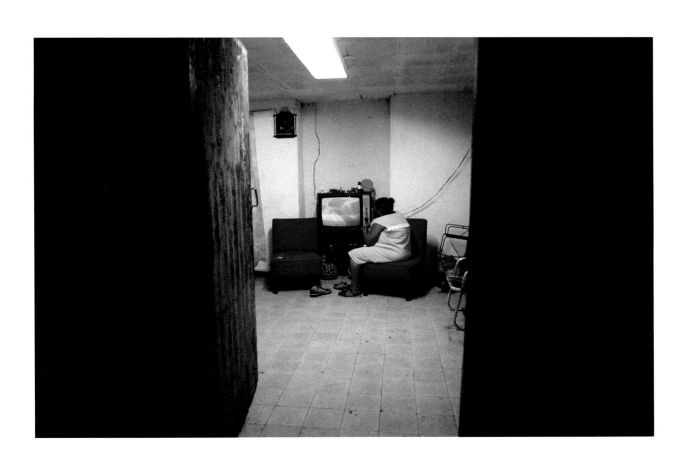

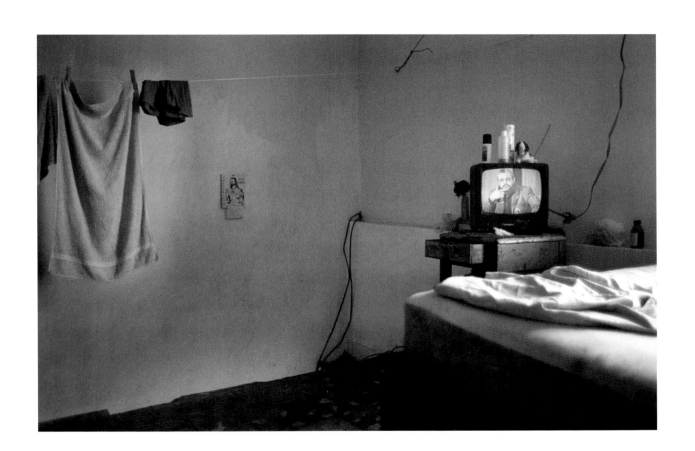

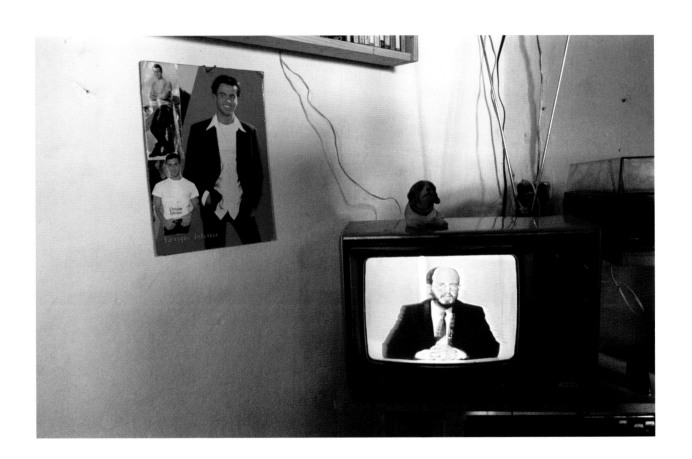

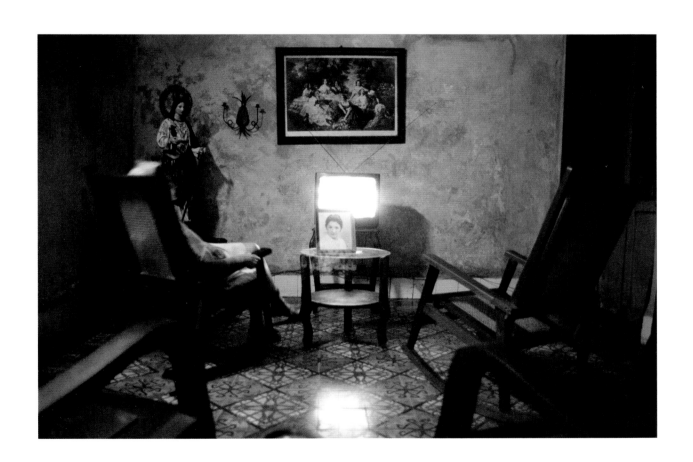

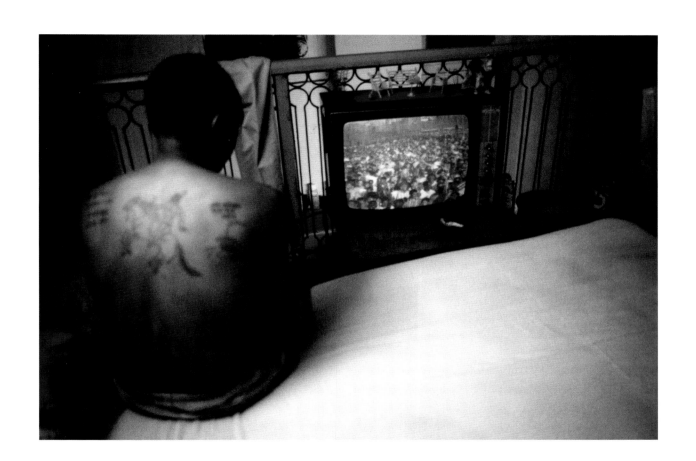

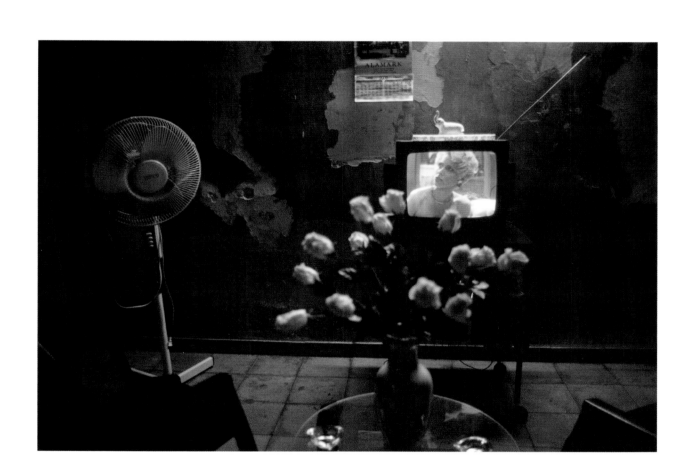

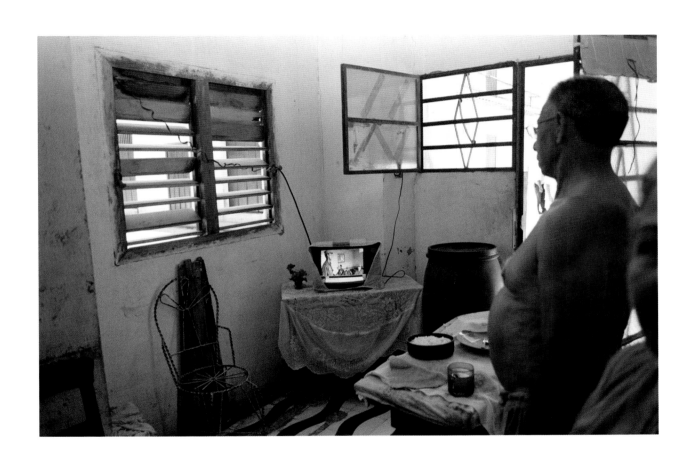

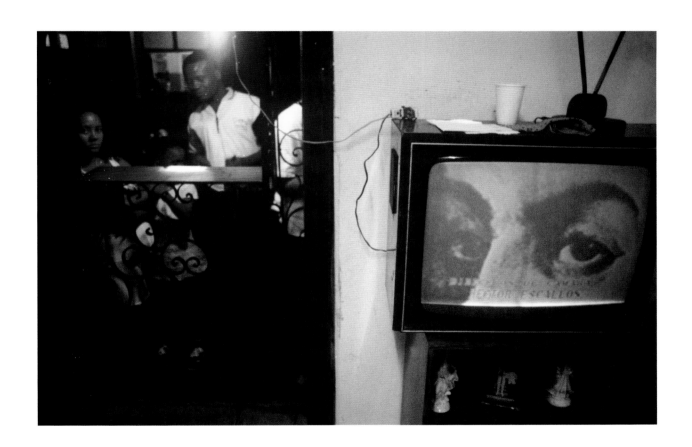

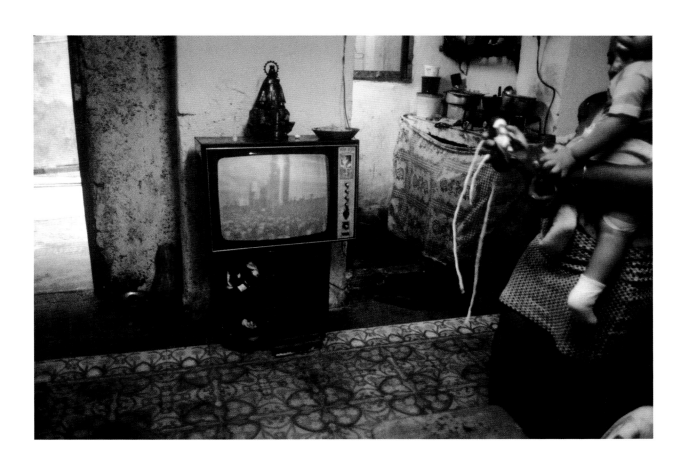

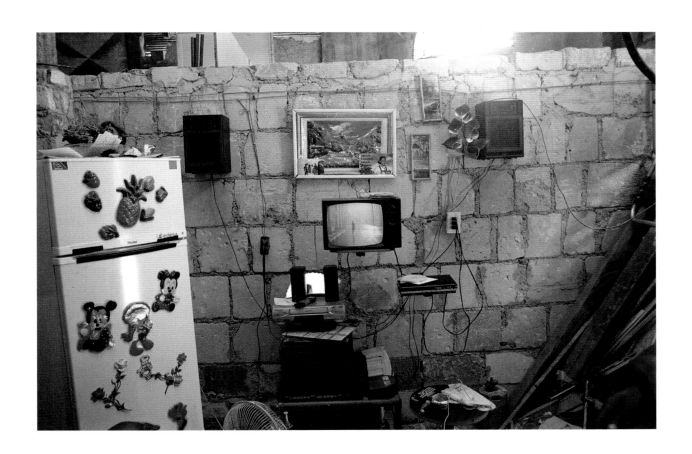

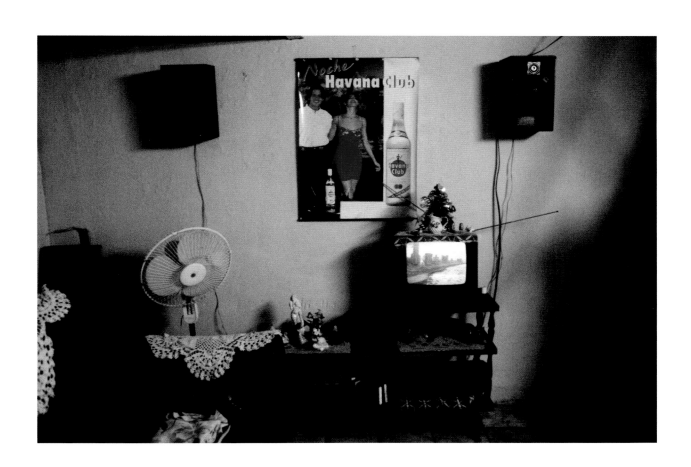

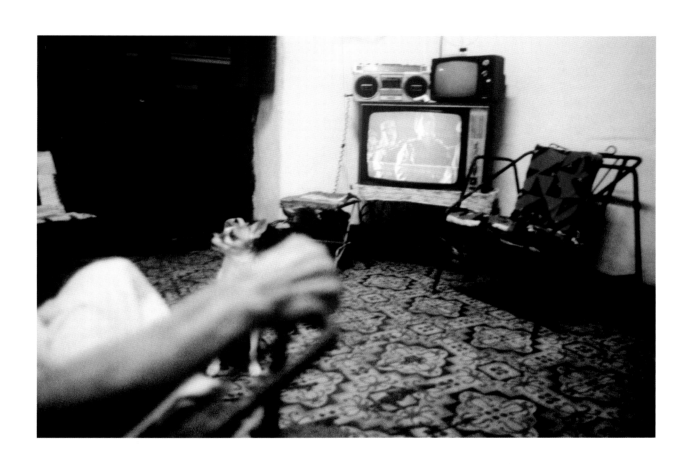

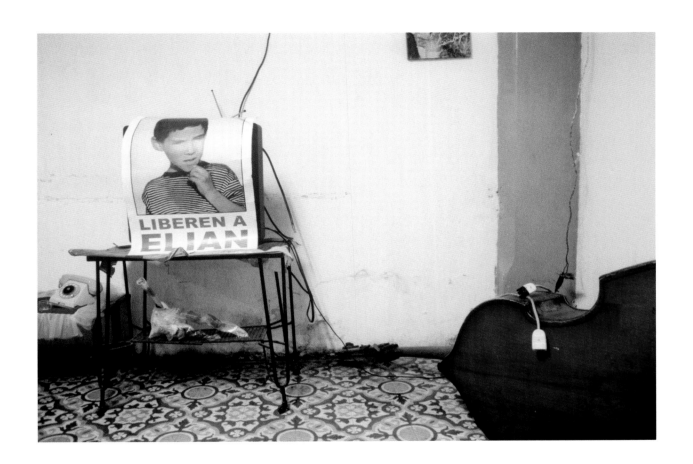

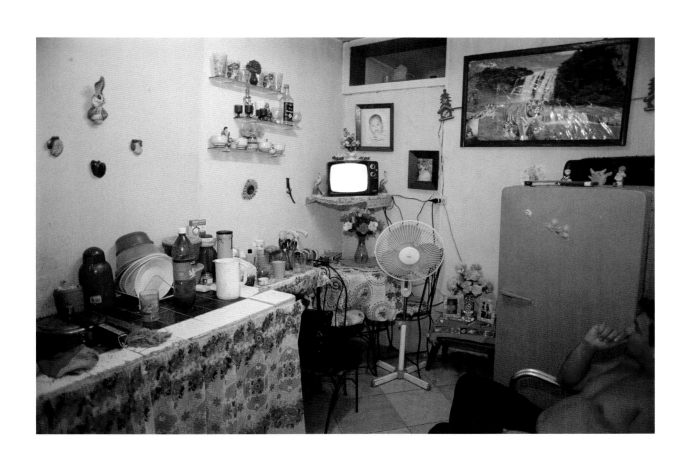

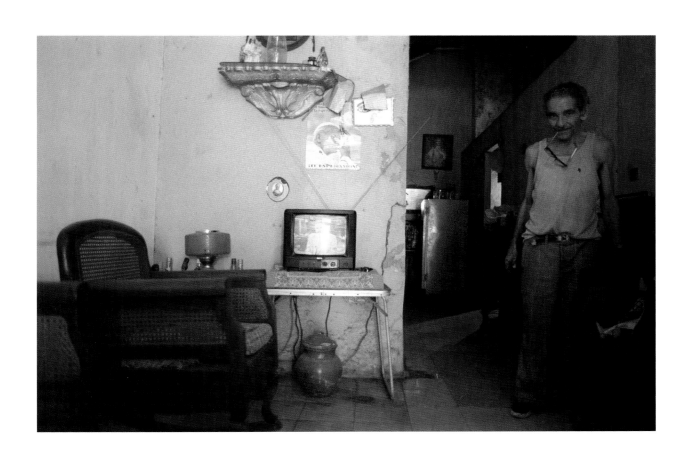

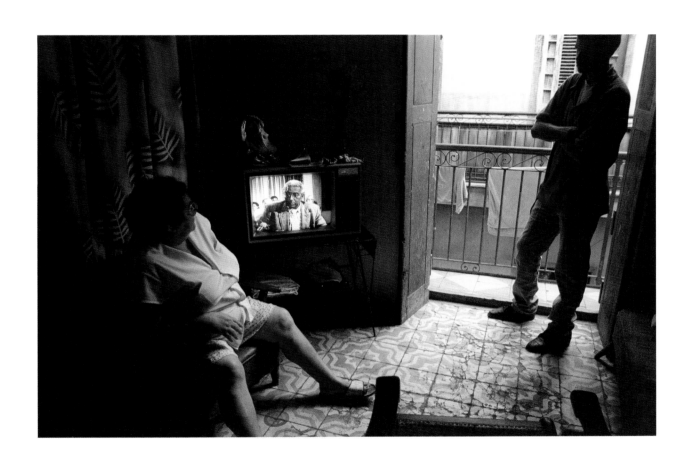

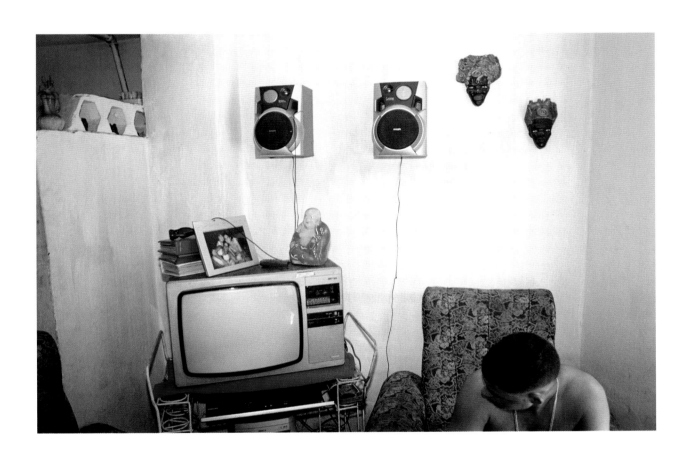

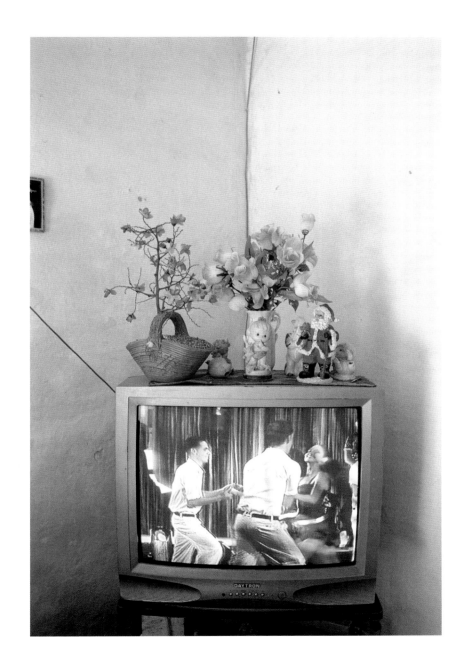

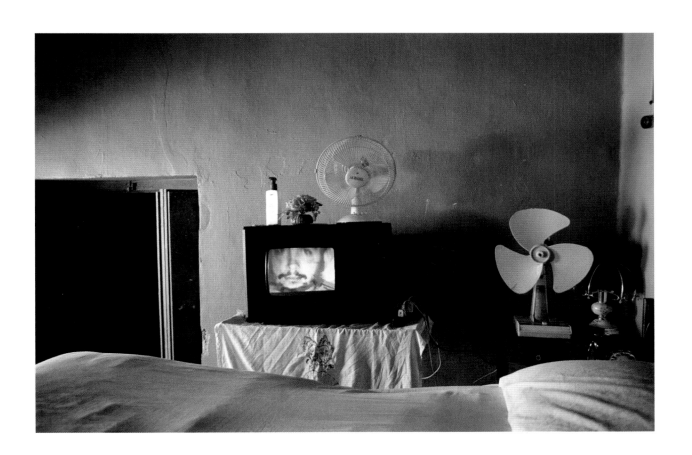

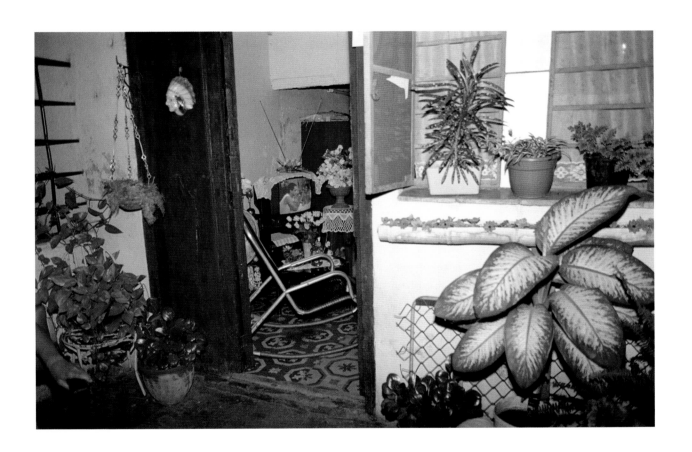

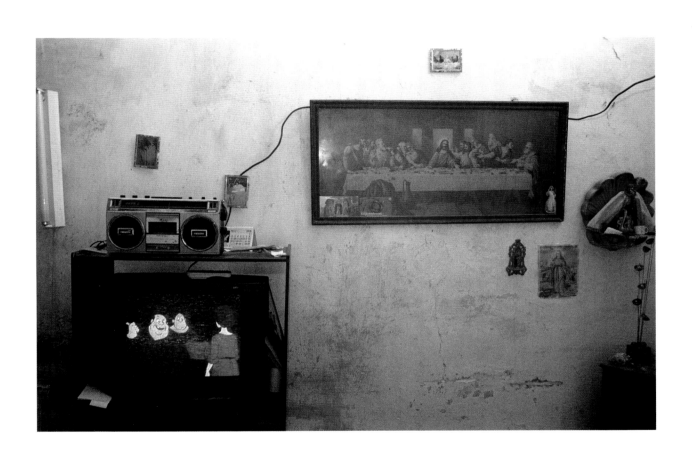

Simone Lueck is a Los Angeles-based photographer originally from St. Paul, Minnesota. Her work is marked by an interest in looking at American cultural territory colored by notions of identity, performance, memory, and glamour. She received a Masters in Fine Art from UC San Diego in 2005 and an Aaron Siskind Foundation individual photographer's fellowship in 2004. Her work has been exhibited in Los Angeles, New York, Tijuana, and Madrid. Simone has self-published her work in limited editions books; the publication "Pictures from the Beach" is included in the permanent archive at the Princeton University Art Museum. Currently she is producing a body of work featuring older women posing as glamorous movie stars. The work is slated for exhibition at the Musée de la Photographie in Belgium and at Kopeikin Gallery in Los Angeles, Winter 2011.